Henri de Toulouse-Lautrec

GREAT ART OF THE AGES

Henri de

GREAT ART OF THE AGES

Toulouse-Lautrec

Text by DOUGLAS COOPER

Harry N. Abrams, Inc. Publishers New York

ON THE COVER:

Quadrille at the Moulin Rouge (detail, front cover). *See page 18*

M. Boileau at the Café (detail, back cover). *See page 26*

MILTON S. FOX, *Editor-in-Chief*

Standard Book Number: 8109-5139-8

Library of Congress Catalog Card Number: 69-19716

All rights reserved. No part of the contents of this book may be reproduced

without the written permission of the publishers, Harry N. Abrams, Incorporated, New York.

Printed and bound in Japan

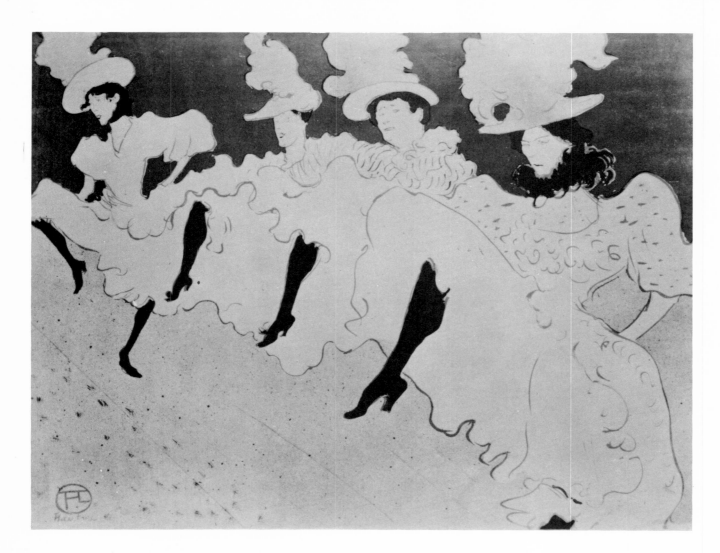

LA TROUPE DE
MLLE. ÉGLANTINE
1896
Lithograph

Henri de Toulouse-Lautrec

(1864–1901)

HENRI DE TOULOUSE-LAUTREC is one of the stranger figures in a century of great but often curious artists. He was descended from a noble family of the Toulouse region of France, whose history could be traced back unbroken almost to the time of Charlemagne and whose members had been noted for centuries as brilliant soldiers, able administrators, or faithful courtiers. Except for his great-grandfather, no earlier member of the family had shown interest or proficiency in the fine arts. Like Cézanne and Degas, Lautrec came of a well-to-do family; so when he devoted himself to art he was not plunged into poverty and did not have to depend on commercial success for his living. He was therefore free to develop his art according to his own inclinations.

Lautrec was a humorous and distinctly eccentric character— qualities inherited in great part from his father, Comte Alphonse de Toulouse-Lautrec, whose eccentricities are almost legendary. But while the father's habits were outrageous to the point of embarrassment, his son, who had considerable charm, always remained within the limits of practical joking and was everywhere welcomed with affection. A sense of fun is a prominent characteristic of Toulouse-Lautrec's art. He often turned this sense of fun against himself, as well as against his father, and he cultivated it in public for practical reasons. Chief among these was a desire to distract attention from his deformed and unlovely appearance, which was more grotesque than ugly. As a result of two accidents in childhood, his legs stopped growing while the remainder of his body developed; so that he only measured four feet six inches in height and required a tiny cane to help him support the weight of his body.

5

Lautrec was as conscious of his abnormal appearance as any court dwarf, and his sensibility was quickly wounded by adverse comments. He himself might laugh at his appearance or even exploit his deformity, but it was not allowed to become a subject of general merriment, for Lautrec was haunted by the idea of being a misfit. This accounts in great part for his enjoyment of disreputable company—circus or music-hall artistes, pimps, prostitutes, perverts, and the like—in which he felt more at ease, less exceptional, and less bored than in that social world to which he belonged by birth and upbringing.

With a mixture of charm, impudence, and coarse but playful wit, Lautrec succeeded in getting himself accepted in this other milieu on terms of equality, so that he was regarded as a jovial companion whose motives were above suspicion and was treated as a homely and harmless monster in whose presence it was possible to behave quite naturally. Lautrec's ability thus to penetrate almost unnoticed behind the façade of gaiety, garishness, and glamour into the sordid intimacy of dull and disenchanted lives greatly favored his artistic needs. For Lautrec was obsessed with discovering life as it is, not as it might or appears to be. And he recorded frankly what he saw in bedrooms, operating theaters, brothels, or bars. His work is without bitterness or mockery, without sentimentality or emotionalism; indeed his emotional detachment, which is one of his salient characteristics, challenges comparison with that of Degas. And this comparison reveals a great difference. For whereas Degas's detachment went hand in hand with increasing blindness, an obsession with the possibilities and the means of art, and an avoidance of worldly entanglements, Lautrec's detachment seems to have grown the more furiously he subjected himself to experiencing new aspects of life. Now, it was largely Lautrec's ability to observe without indulging in social criticism which saved his work from falling into caricature or becoming mere illustration, and this is an essential part of his greatness.

Any study of Lautrec's work must, I think, begin from an account of his personality and outlook. For the work is the man, and at least half of one's enjoyment depends on coming to terms with his charming and engaging personality. It is not purely as a painter that Lautrec merits the adjective "great." The difference between the so-called "painterly" painters—Manet, Monet, Degas, Cézanne, even Vuillard and Bonnard—who attempted in their work to re-create their sensuous experiences, and Lautrec, who was a tireless observer and recorder of facts rather than of effects or sensations, is both real and profound. Lautrec's work is almost more important for what the artist has to say about human beings than for the artistry with which he says it. Actually, Lautrec was a fine technician, but he found that the effects which he wanted could be obtained without cultivating a virtuoso technique and without striving to master the full possibilities of the medium. So he did not hesitate to borrow compositions from other artists and adopted a quite personal method of manipulating paint which was thoroughly adequate to his purposes but which was not of prime consequence. In the field of graphic art, however, exactly the opposite is true, for in lithography Lautrec's technical achievements were highly original and significant. The effects which Lautrec, like other artists of his generation—Munch, Hodler, Seurat, Gauguin—sought to achieve, depended largely on an expressive use of line, and lithography was a medium perfectly suited to his needs. Having discovered this medium, his daring knew no bounds; he explored every technical possibility to the full, developed a remarkable sense of color, and in the space of ten years revolutionized the technique of lithography somewhat as Daumier had done fifty years earlier and as Picasso has done again fifty years later. This discovery made possible much of Lautrec's artistic development, for in his hands color lithography became a rival technique to oil paint. He learned to capture in his lithographs effects similar to those in his paintings, and in the same way repercussions of his lithographic discoveries can be seen in the style of his later paintings. Yet Lautrec's instinctive feeling for a pure use of both media was so acute that he never confused the two techniques. Stylistically, therefore, Lautrec's paintings and lithographs form two different aspects of his work, just as they do with Daumier. But unlike Daumier, these two aspects of Lautrec's work cannot be considered separately, for they are bound together by the fact that in both he handled the same themes in the same way, and by the fact that both are based on the same drawings and sketches from life. These sketches were vital notes made on the spot, with no particular thought for the medium which they were to serve, and were intended simply to stimulate his creative impulse by reminding him of some visual experience. In short, they were the raw material from which Lautrec might ultimately derive a painting or a lithograph, and there are several examples of a composition being executed in both mediums. Lautrec himself did not distinguish in importance between them, just as he made no distinction between "commercial" and "pure" art. So in this we must follow him and not try to create artificial divisions.

Henri-Marie-Raymond de Toulouse-Lautrec-Monfa, to give him his full name, was born at Albi on November 24, 1864, and he seems to have shown artistic inclinations in earliest youth. For when, at the age of three, he was told that he could not sign as a witness at his brother's christening because he did not know how to write, he replied: "Well then, I'll draw an ox." By the age of ten his passion for drawing was well developed, and he used to fill his lesson books with sketches of animals and fellow pupils which show how sharp were his powers of observation. Probably Lautrec's artistic urge was so strong that he would anyway have become a painter, even against his father's wishes. However, his talent might not have been allowed to develop so early and he might not have devoted himself exclusively to art but for two tragic accidents. In May 1878 and again in August 1879 he fell, breaking first his left and then his right leg. Rachitic and delicate since birth, Lautrec's convalescence was on each occasion prolonged. And it was during these years of enforced idleness that he began to paint seriously. Then, at the age of seventeen, when he realized that he would never again lead an active outdoor life, he determined that art should be his profession.

Since childhood Lautrec had known his father's friend René

OPPOSITE PAGE:
PORTRAIT OF THE COMTESSE
A. DE TOULOUSE-LAUTREC
IN THE SALON AT MALROMÉ

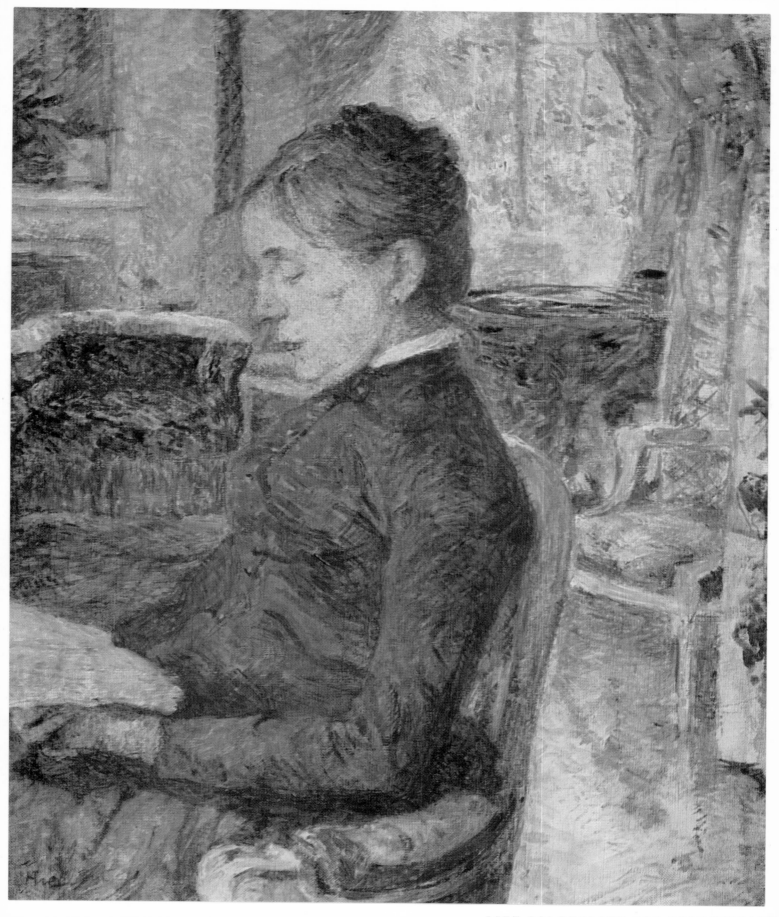

LIFT COLORPLATE FOR COMMENTARY

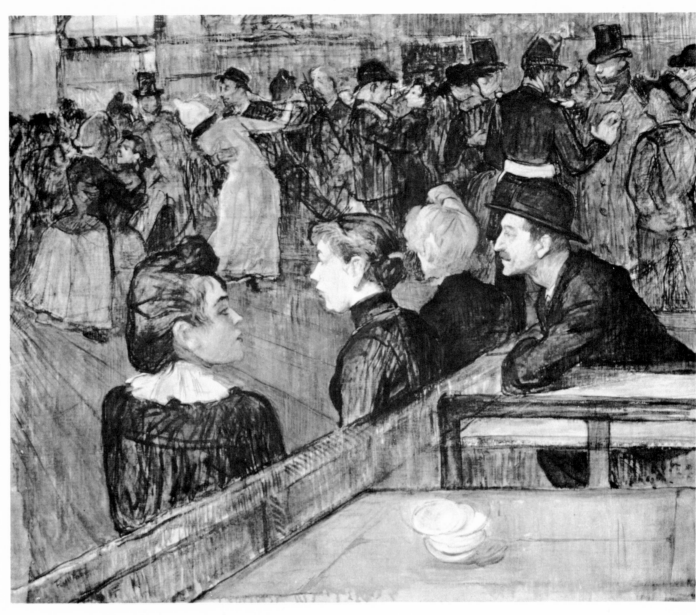

Princeteau, a strange deaf-mute painter who specialized in pictures of horses and dogs. This man assumed responsibility for the first stages of his artistic education. Princeteau took Lautrec to the theater and circus in Paris, praised his "great connoisseurship of horses and dogs," and encouraged him, between 1878 and 1882, to paint a great number of what may loosely be termed "sporting pictures"—scenes of horses being ridden or driven along the promenade at Nice, scenes of cavalry life, pictures of sporting dogs, of boats, and of sailors. Generally speaking, these pictures are full of exaggerated movement and are painted in a fumbling technique, yet they are full of life and must be accounted no mean achievement for an almost self-taught boy between the ages of fourteen and eighteen. However, Lautrec soon exhausted the benefits of Princeteau's training, and in March 1882 he enrolled in the studio of Léon Bonnat, a highly successful academic artist. Bonnat made him work hard at drawing from

life and taught him the principles of composition. As a result his work became much firmer and more controlled, and from this date his adult personality began to develop.

In 1882 Lautrec began to paint portraits of his mother and of workers on the family estate at Céleyran. Many of these were outdoor scenes and they mark a great advance on his previous work because they show that in the meanwhile he had become familiar with Impressionist painting, especially with the open-air painting of Manet in his later years. Yet even so they are no more than the work of a gifted student not fully in control of the pictorial means. Nevertheless they are important because they show how early Lautrec developed modern and unacademic tendencies; and they have an added interest because they form a curious counterpart to the scenes of Dutch peasant life painted almost at the same date by Van Gogh, then also at the beginning of his artistic career. But where Lautrec's pictures are

natural, calm, and sophisticated, Van Gogh's, in which great use is made of heavy chiaroscuro, are uncouth, tense, and forceful. Yet both artists have a similar and striking humanity, and both were concerned with individuals. This was the new note which they introduced into painting.

In the autumn of 1882 Bonnat closed his studio and Lautrec then went to study under Fernand Cormon, another academic artist. He remained in this studio for about five years, that is to say until 1887, and there became friendly with many adventurous young artists such as Anquetin, Émile Bernard, and Van Gogh, who broadened his vision and greatly encouraged his unacademic tendencies. Thus, under the joint influences of the dull but effective teaching of Cormon, the diverse artistic styles and personalities with which Lautrec and his fellow students were in contact, and lastly his own spontaneous enthusiasms, Lautrec gradually became master of the technical means and evolved a style of his own. But we must not forget that this was no easy achievement. Lautrec really struggled to make of himself a proficient artist, and one can judge his enormous progress by a picture such as the portrait of his mother reading, of 1887 (page 7). This too is an Impressionist painting, but of quite another order. There is nothing casual about this picture; it is carefully composed and the background consists of an elaborate play of verticals and horizontals produced by the lines of the furniture. Then—and especially in this Lautrec has not followed Impressionist usage—the figure is not enveloped in its surroundings, it is not treated like a piece of furniture or as a focus of light. The Comtesse has been brought into the immediate foreground and the picture is dominated by her human presence. Here we have touched on one of Lautrec's most original and fundamental characteristics. Living creatures, whether human beings or animals, had a special significance for him; still life, domestic interiors, and landscape did not really interest him. "Nothing exists but the figure," he once said to his friend and biographer Joyant. "Landscape is nothing, and should be nothing but an accessory. Landscape should be used only to make the character of the figure more intelligible."

Lautrec's struggle to conquer his ineptness has its parallels in Gauguin and Van Gogh. All three artists had this in common initially: that they had something urgent to communicate and no adequate means of doing so. But whereas Gauguin, who was less naturally talented and clearly had less feeling for humanity, ultimately side-stepped many technical difficulties which he could not overcome and created the bloodless style called Synthetism, Lautrec and Van Gogh slaved—and not in vain—to forge an idiom which would be infused with their intense feeling for life and would still be artistically valid.

Lautrec's debt to other artists was always considerable and it is therefore interesting that one of his fellow students at Cormon's has left us an authentic record of his artistic tastes. He says that Lautrec admired Velázquez, Goya, Ingres, Renoir, and Forain, and that he "was fascinated by the Japanese masters." But there was one painter whom he admired above all others—Degas. Obviously I cannot deal here with the relative influence

of each of these, but it is essential to say something about the two most important—Degas and the Japanese. Lautrec's admiration for Degas dates from about 1883, and the two artists probably met in 1884 when they had studios in the same building in Montmartre. Now, there is no doubt that Lautrec owed a great deal to his discovery of the work of Degas, for he borrowed from the older man not only forms of composition but particularly types of subject matter. Yet despite this link there is an unmistakable difference in spirit between them. For where Degas's prime concern was with recording his visual experiences exactly, Lautrec thought primarily of presenting a factual statement of physical truth and reality. This is very noticeable in his portraits, which, numerically at any rate, form an important part of his oeuvre between 1890 and 1900. In these above all, Lautrec displayed his control of impish or sardonic tendencies to such effect that the balance between reality and art is perfectly held. Only rarely did he indulge in distortion or caricature for its own sake—the portraits of Yvette Guilbert and Oscar Wilde are obvious examples—and even then such exaggerations as he permitted himself were more often humorously applied to clothes or ornaments than to faces. Using color and line with great economy, Lautrec sought to present the essential

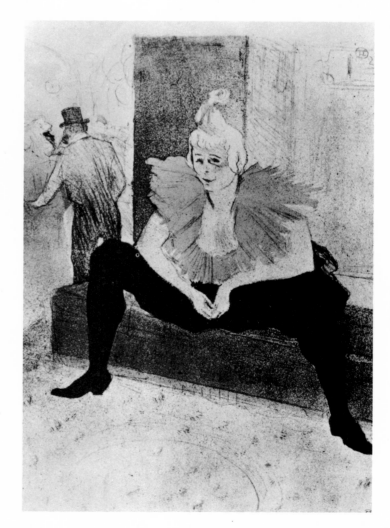

THE CLOWNESS
CHA-U-KAO
1896. Lithograph

facts about the human character, about human lives and human activities, an aim which might easily have led him into mere reportage like the work of Forain or Guys. But because his use of these pictorial means was always pure, his pictures could have a subject although they did not tell a story.

On the whole Lautrec was not a great innovator, but in one respect—his open-minded and outspoken attitude toward sex—he was unique in his time. Man's sexual activities form the subject of many of Lautrec's greatest pictures, but even in these he merely recorded what he saw dispassionately and with frankness. And because he resisted the temptation to be shocking or sensational, because he never played up the element of grossness or vice, the naturalism of these works is never salacious or disgusting. Sometimes, however, as in *The Salon in the Rue des Moulins* (page 29), Lautrec's sense of humor bursts through his reserve, and on such occasions his extraordinary humanity and powers of detached observation are still more clearly revealed. Try to imagine the same scene painted by Félicien Rops, Forain, Rouault, or George Grosz and then you will begin to perceive the real warmth which is characteristic of Lautrec.

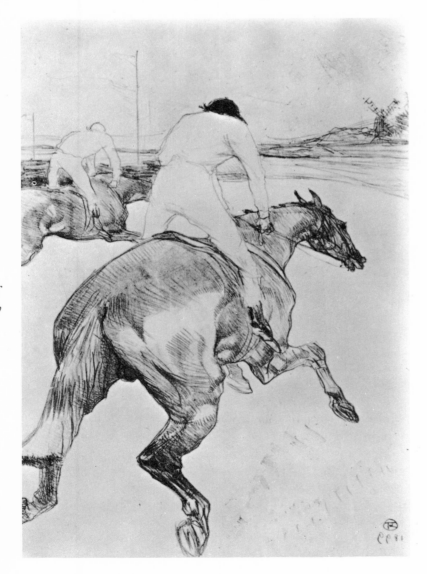

THE JOCKEY
1900. Lithograph

Thus far I have considered Lautrec's development more or less chronologically, but this ceases to be necessary after his years of apprenticeship. For after 1888, when he evolved his mature style, until 1901, when he died, the spirit of his work did not change, nor did his technique vary, except during the last two years of his life. So now I must briefly consider Lautrec's mature style and his innovations. The real turning point in Lautrec's work is marked by his first circus picture—*Cirque Fernando: The Equestrienne*, of 1888 (page 13)—in which he broke with Impressionism and with the Renaissance conception of spatial representation. Suddenly Lautrec gave up painting effects of light, and started to take liberties with natural appearances and to make a bold use of local color; he also tried to create an illusion of depth according to a new pictorial logic. In this he showed how completely he was a man of his own time; for his daring step and the solution he found were completely in line with the methods adopted at the same date, and for similar reasons, by Seurat, Gauguin, and the Nabis. But in contrast to Gauguin and the Nabis, Lautrec lived what he painted and was not prepared to sacrifice anything of human truth to artistic convention. He therefore had to resolve the element of artificiality which mars *Cirque Fernando* and which results from a sort of conflict between realism and pictorial necessity due to his lack of experience in the science of picture making. This meant evolving a means of spatial representation which would allow his human beings to exist in the round without violating the flat surface of his canvas. He found his solution through studying Japanese prints.

Japanese prints had first attracted the attention of French artists in the early 1860's, and the influence of the Japanese styles rapidly spread. Yet, although many artists were affected, each seems only to have borrowed those elements which suited his purpose. Thus Manet seized on the surface contrasts of dark and light, and Degas absorbed the principle of cutting figures at unexpected angles, while Gauguin and Van Gogh adopted the emphatic outlines and the calligraphy. Lautrec, on the other hand, who had begun to buy Japanese prints in the early 1880's, took over and adapted a great deal. He learned to use expressive outlines, to give his compositions a rhythmic linear unity, and to play with subtly contrasting curves and angles; he cut down light and shade as a means of modeling, though he sometimes used directed shafts of light to pick out expressive details; he learned to use silhouettes and simple masses of flat color; he saw how to include purely decorative elements without destroying realism; and finally he discovered ways of simulating spatial recession—by setting the eye level more than halfway up the canvas, by using flat, parallel, unconnected planes, by off-centering a composition, and by using abruptly receding shallow diagonals, often in false perspective. But Lautrec did not adopt the simpering mannerism and masklike expressions of the Japanese and never reduced a face to a conventional formula.

Nor was this the end of Lautrec's innovations. He also needed a style which was bold but not labored, and a technique in which he could work quickly. For Lautrec was not concerned with re-creating every detail of an optical sensation. His aim was to

catch life on the wing, and he wanted to preserve a stylistic continuity between his hasty but lively instantaneous sketches and the more considered paintings or lithographs into which they developed. That is why, after 1888, he adopted a much freer form of brushwork, using long, sweeping strokes for drawing outlines and a network of slightly shorter strokes in the enclosed areas for creating surface modeling and texture. At the same time Lautrec's color schemes became bolder and more brilliant and his paint more dry. And the effect of creating this essentially personal idiom was to make Lautrec's work at once more spontaneous and more vital and to usher in a period of ten years during which he was at the height of his powers. Thus Lautrec must ultimately be judged on the works which he produced between 1888 and 1898, for during that period he created all his most inspired, most individual, and most impressive pictures.

Lautrec led a full and busy life, the many facets of which are reflected in the works of his great period. He was a devotee of the theater, the circus, and the music hall; he was an enthusiastic spectator at sporting events such as bicycle races; he watched human dramas in the law courts, and was no less fascinated by the spectacle of Dr. Péan operating on his patients; he was on easy terms with the inmates of several Parisian brothels, and sometimes spent several days in one of them as a curious observer. Almost any violent manifestation of life seems to have attracted him, especially if it was accompanied by some manifestation of creative artistry. Nevertheless he worked regularly and extremely hard. But Lautrec also lived an increasingly dissipated life, making a nightly round of the cabarets, dance halls, and bars of Montmartre and drinking to excess. All this was too much to ask even of a robust constitution, yet for many years his hand did not falter. However, after 1897 his physical and mental condition began noticeably to deteriorate; then in February 1899 he had a serious breakdown. For a few months he was interned in a sanatorium, but his recovery was astonishingly rapid, and to prove his sanity to his doctors he began, after only four weeks, to make drawings from memory of circus scenes. These lack the *brio* of his earlier work and are stilted, yet his hand still retained some of its cunning even though it was for the first time deprived of a direct visual stimulus. Not until December 1899, however, did Lautrec again begin to work seriously. But then he also resumed his drinking habits, and from this date his work rapidly deteriorated. Gone is the biting, swinging line in favor of a style based on tonal values and freer brushwork. But this was a style for which he had no real aptitude, and the fumbling pictures which he painted during the last two years of his life are a heavy-handed and tragic aftermath to a decade of exceptional brilliance. This period was short-lived. In March 1901 Lautrec had another breakdown, and on September 9th of that year he died, aged thirty-seven.

The problem of situating Lautrec as an artist is considerable, for he cannot be reckoned among the very great even of his own period, although one would not wish to deny the obvious importance of his very individual contribution. Perhaps then it is simplest to consider him historically first. For he was a vital link

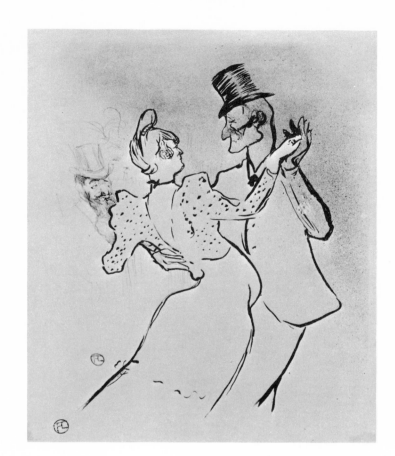

LA GOULUE
AND VALENTIN
1894. Lithograph

in the chain of reaction against Impressionism, against *la belle peinture* as such, and against the cosy, smug little bourgeois world which the Impressionists depicted. For all that he was *fin de siècle*, Lautrec was not reactionary. Stylistically he takes his place beside Seurat, Gauguin, and Van Gogh and stands in sharp contrast to belated Impressionists such as Bonnard and Vuillard. Lautrec enlarged the subject matter of art and introduced a new element of real humanity. Yet his influence on painting has been strangely small and scarcely extends beyond the early work of Rouault and of Picasso before 1904.

As a painter Lautrec was not a great technical innovator, though he was a very fine technician. As a graphic artist, on the other hand, he was supreme and his influence has been considerable. For he experimented with and developed the art of lithography, and imposed a style on commercial art which is still unsurpassed. But as an artistic personality Lautrec quite rightly has a high place among his contemporaries because he made no concessions to popular taste—that is to say, because he was neither an illustrator nor a propagandist—and because his pictures were about life at a time when, to say the least, this was unfashionable. What more is there to add, except that Lautrec's works are always enjoyable human records. That is a very great deal. But in addition his pictures are precious historic documents, which tell us as much as many a novelist or historian about the life and moral outlook of his generation. That is perhaps a greater value. For the rest he was one of the most engaging and amazing personalities in the history of art.

Cirque Fernando: The Equestrienne

38¾ × 63½″

THE ART INSTITUTE OF CHICAGO (*Gift of Tiffany and Margaret Blake*)

THIS PICTURE IS OF GREAT SIGNIFICANCE in the work of Lautrec because it was his first attempt at a composition with several figures, his first great pictorial experiment, and his first circus scene. In it he broke with the naturalistic representation which he had used hitherto, and tried to create a sense of space and movement by new means.

The pictorial space is limited by the curving balustrade of the ring, which divides the picture roughly in half, and the effect of depth is further reduced by looking down on the ring, the plane of which thus rises up the surface of the canvas. The whole action therefore appears flattened, and this effect is heightened by the fact that the distance separating the ringmaster from the two performing clowns is not precisely indicated, and by the exaggerated foreshortening in the drawing of the cantering horse. As a result all the performers appear to be roughly on the same plane.

We do not know exactly when Lautrec painted *The Equestrienne*, but it was probably at the end of 1888. At all events, it hung in the foyer of the Moulin Rouge from its opening in October 1889.

The Equestrienne was a sudden experiment, and the picture is somewhat marred by caricature, but it is interesting to note the importance of linear rhythms and expressive outlines in this picture because from now on Lautrec began to rely increasingly on these elements.

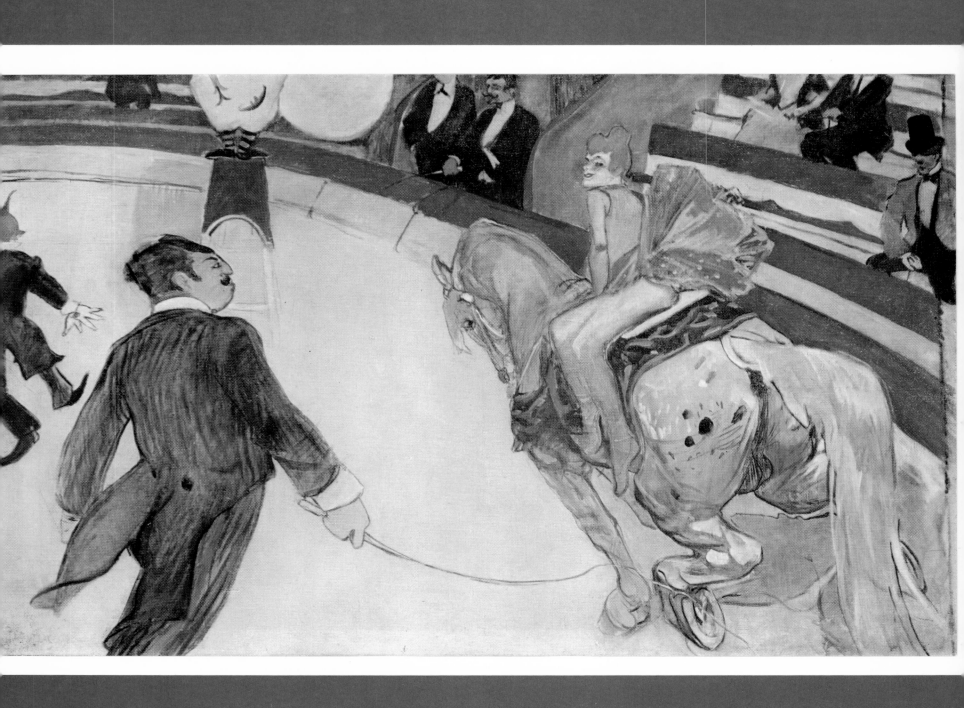

PAINTED IN 1890, PARIS

At the Moulin Rouge: The Dance

45 × 59″

COLLECTION HENRY B. McILHENNY, PHILADELPHIA

THIS WAS LAUTREC'S THIRD and most successful major composition; it was painted about a year later than *At the Moulin de la Galette* (page 8). Here the arrangement is more elaborate, being based on three parallel planes: a background plane of a line of figures as before, though here the figures are static and more individualized; a central plane, in which La Goulue and her partner Valentin-le-Désossé are performing their violent dance; and a foreground plane traversed by impassive spectators, two women and a man, who are not involved in the action.

Again the depth of the pictorial space is limited by the placing of the foreground figures, which help to encircle the dancers; by the line of background figures which presses forward; and by the lines of the floor boards drawn in false perspective. As in *At the Moulin de la Galette,* recession is obtained by an abrupt diagonal running from the two women in the right foreground to the top-hatted man and the red-coated page in the left background; this time, however, it is felt and not drawn. The composition is further held together by the meandering lines of the shadows on the floor. The white-bearded figure in the right background is Lautrec's father; the group of four men in the center background are the artist's friends Varney, Guibert, Sescau, and Gauzi (behind); the woman in a black cape is Jane Avril.

This picture was acquired in 1890 by Joseph Oller, director of the Moulin Rouge, and hung in the entrance there. The Moulin Rouge, a music hall in the Boulevard de Clichy, was opened in October 1889. It had an immediate and sensational success and was frequented by a fashionable public. Apart from the main dance floor, with a *promenoir* down each side and a gallery above for spectators, there was a large garden behind in which the crowds could sit or stroll. The nightly performance began with a concert of comic or sentimental songs—Yvette Guilbert made one of her first appearances there in 1890—but the main attraction (between ten o'clock and midnight) was the dancing, particularly the *quadrille naturaliste* (see page 18) performed by the famous Montmartre dancers—La Goulue, Valentin, Grille d'Egoût, Môme Fromage, and Jane Avril. Between 1890 and 1896 Lautrec executed at least thirty paintings of scenes at the Moulin Rouge, yet it is characteristic that they tell us a great deal about a few of the people who frequented it and almost nothing about its structure or appearance.

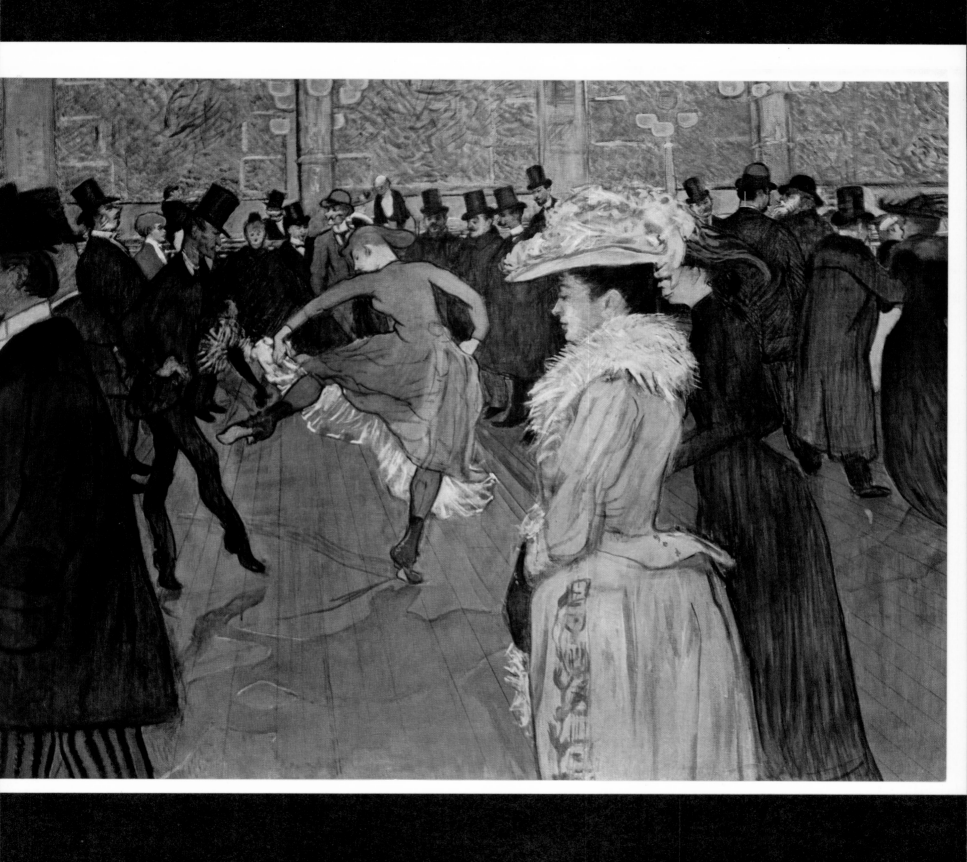

PAINTED IN FEBRUARY 1891, PARIS

À la Mie (Last Crumbs)

21 × 26¾″

MUSEUM OF FINE ARTS, BOSTON

AS A PICTURE OF HUMAN DEGRADATION *À la Mie* is unique in Lautrec's work, but
this vision of disillusionment, cynicism, and vice is a product of the artist's imagina-
tion. There exists a photograph by Paul Sescau showing that in fact this picture was
posed by Lautrec's friend Maurice Guibert and a young, attractive Montmartre model.
This is particularly interesting because it reveals that on this occasion at least Lautrec
was prepared to disregard truth in order to achieve a desired effect.

Maurice Guibert was one of Lautrec's constant companions and appears, usually
with Sescau, in many of his Moulin Rouge pictures. Lautrec never painted a straight-
forward, serious portrait of Guibert, although he made at least twenty drawings and
caricatures of him—one of the last (1900) shows him in pursuit of a girl on the quayside
at Bordeaux—and frequently included him among the crowd both in paintings and
lithographs. Guibert was something of an amateur painter, though his profession was
that of salesman for Moët et Chandon champagne. In real life he was jovial and charm-
ing and had nothing about him of the sinister *apache* who appears here.

This picture is an example of Lautrec painting under the influence of Degas, for it
clearly derives from *L'Absinthe*. It was exhibited at the Salon des Indépendants in
March 1891.

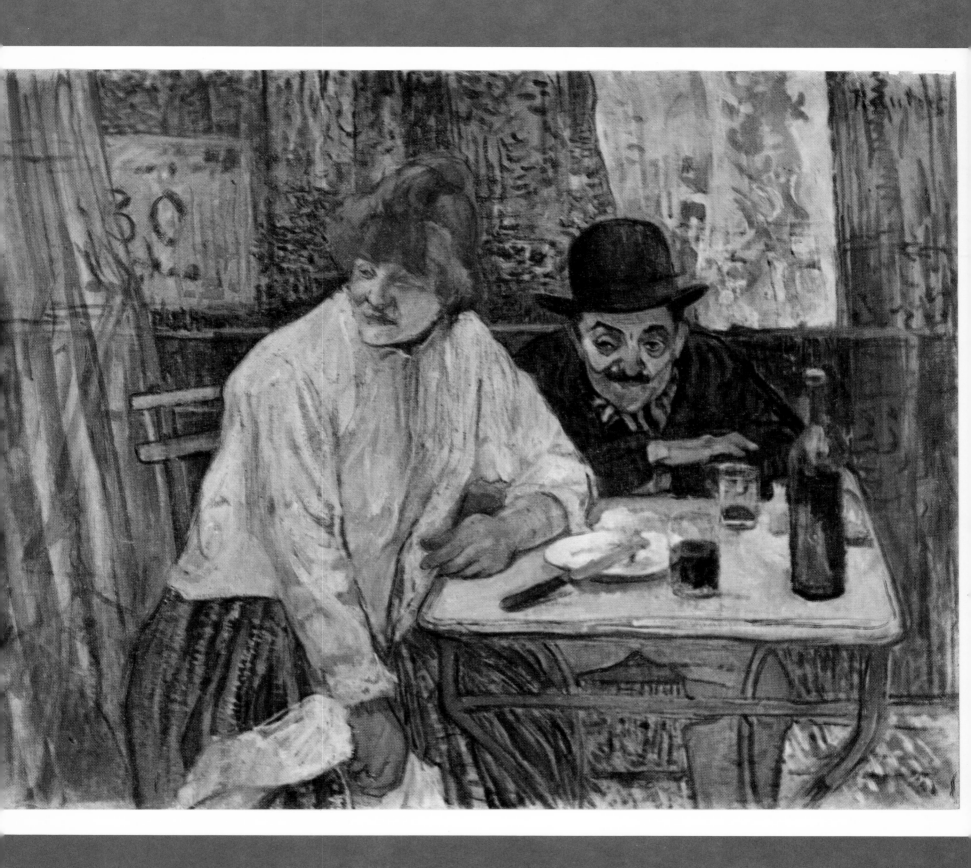

PAINTED IN 1892, PARIS

Quadrille at the Moulin Rouge

$31\frac{1}{2} \times 23\frac{3}{4}''$

NATIONAL GALLERY OF ART, WASHINGTON, D. C.

(Chester Dale Collection)

HERE LAUTREC TAKES US BACK onto the dance floor at the Moulin, where the famous *quadrille* is about to start. The fashionable public is wandering back to tables in the *promenoir* and in a few minutes the floor will have been taken over by the troupe of professional dancers, one of whom, looking arrogantly and disdainfully at the spectators, has already planted herself in position.

 The *quadrille naturaliste,* as it was called, was a development of the cancan, a dance created by Céleste Mogador which had been all the rage at halls such as Mabille or Valentino between 1850 and 1870. After the Franco-Prussian War, the cancan went out of fashion until it was revived in the form of the *quadrille* by La Goulue and her partner Valentin. It was danced in groups of four people.

 One sees here how close Lautrec could get to social criticism without spoiling his picture by moralizing or by caricature.

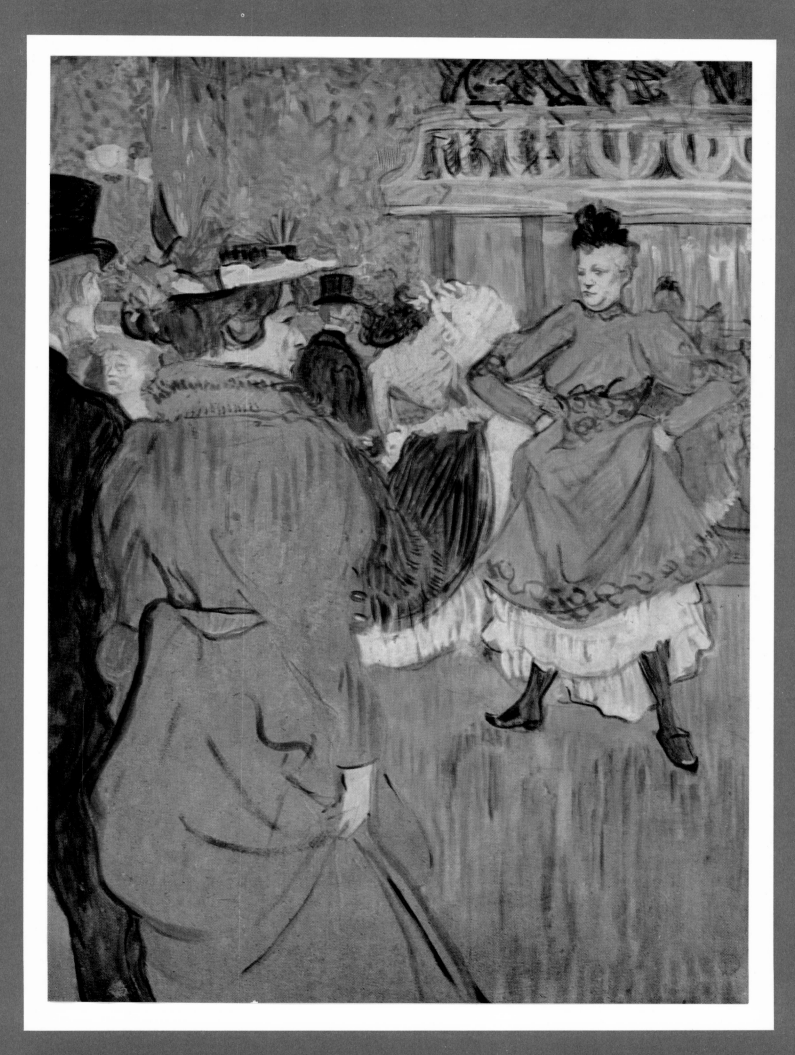

PAINTED IN WINTER 1892, PARIS

A Corner in a Dance Hall

40 × 39″

NATIONAL GALLERY OF ART, WASHINGTON, D. C.

(*Chester Dale Collection*)

HERE LAUTREC TAKES US ONCE AGAIN into the *promenoir* of some music hall or cabaret, though this time it is a less fashionable establishment than the Moulin Rouge. This picture has been said to represent the Moulin de la Galette, but the identification is doubtful. Dancers and prostitutes are wandering about among the tables at which clients are seated, and the woman in the long black coat has her eye on the man in the bowler hat. All the elements of a short story are present, yet this is not in any sense a literary picture. As usual, Lautrec has overlooked the crowd and has concentrated on a few figures, making a picture out of the contrast in style between the three different types of woman. Here one sees him adopting a new solution for avoiding the problem of space, namely by looking up at the figures from below and thus shutting out the background.

This is an unusually sad picture for Lautrec, the mood being set by the morose and dreamy expression of the woman in the foreground. Again one is reminded of Degas's *L'Absinthe,* and even of Manet's *La Prune.* Here is another work in which the artist could easily have resorted to exaggeration or caricature to heighten his effect, but the fact that he has not done so brings home to us Lautrec's fundamental humanity and his ability to remain emotionally detached. In this picture Lautrec appears at his noblest and best.

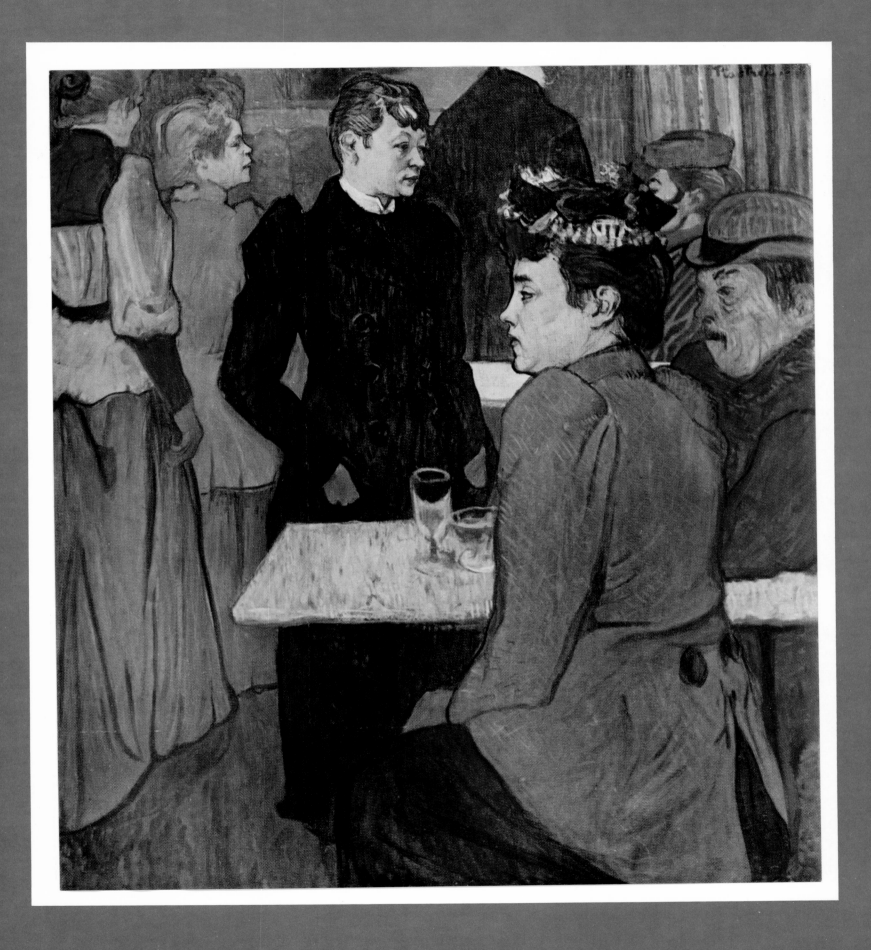

La Goulue Entering the Moulin Rouge

31½ × 23″

THE MUSEUM OF MODERN ART, NEW YORK
(Gift of Mrs. David M. Levy)

IN 1892 LAUTREC CONCERNED HIMSELF predominantly with the Moulin Rouge and two of its leading dancers, La Goulue and Jane Avril. Here La Goulue is entering the Moulin, accompanied by her friend Môme Fromage on the left and a young dancer on the right. The three women are brilliantly characterized by the differences in their costumes and coiffures, and these are given further point by the contrast beween the fine, grasping hands of La Goulue and the coarse, insensitive hand of Môme Fromage. The lecherous man in the background appears like an incarnation of fate.

Louise Weber (1870–1929), known as La Goulue (The Glutton), was an Alsatian laundry-girl who was brought to Paris by the impresario Marcel Astruc in 1886. She first attracted attention at the Moulin de la Galette, where she was seen by Lautrec, who included her in several pictures in 1886–1887. In 1889 she played the leading part in a revue there; but then she moved first to the Jardin de Paris and in the autumn, when it opened, to the Moulin Rouge, where she became the star performer.

All those who knew La Goulue agree that she "was pretty and attractive to look at in a vulgar way" (Yvette Guilbert), but that she was also haughty, ferocious, brazen, coarse, and wanton. Her success was not, however, of long duration, for she ate and drank heavily. By 1895 she had already lost her charms and had grown too fat to perform in Montmartre; thereafter she was reduced to earning a living by performing a *danse du ventre* in a booth at suburban fairs.

She appealed to Lautrec to decorate this booth, and he, rising to the occasion, painted two large panels (now in The Louvre) in which she is shown giving a brilliant display in front of a smart, admiring audience composed of many of the artist's friends. By 1905 La Goulue had become too fat to perform any more, and the later years of her life were spent in penury. She was the subject of at least a dozen pictures by Lautrec painted between 1886 and 1895.

La Goulue's partner in the *quadrille* was Valentin-le-Désossé, who is shown dancing with her in *At the Moulin Rouge: The Dance* (page 14). Cadaverous-looking, he was an extraordinarily agile dancer, with a body so flexible that his bones seemed (as his name implies) to be made of rubber. Valentin danced for the love of dancing and was not salaried like the women; he owned a small café in the Rue Coquillière, where he worked during the day.

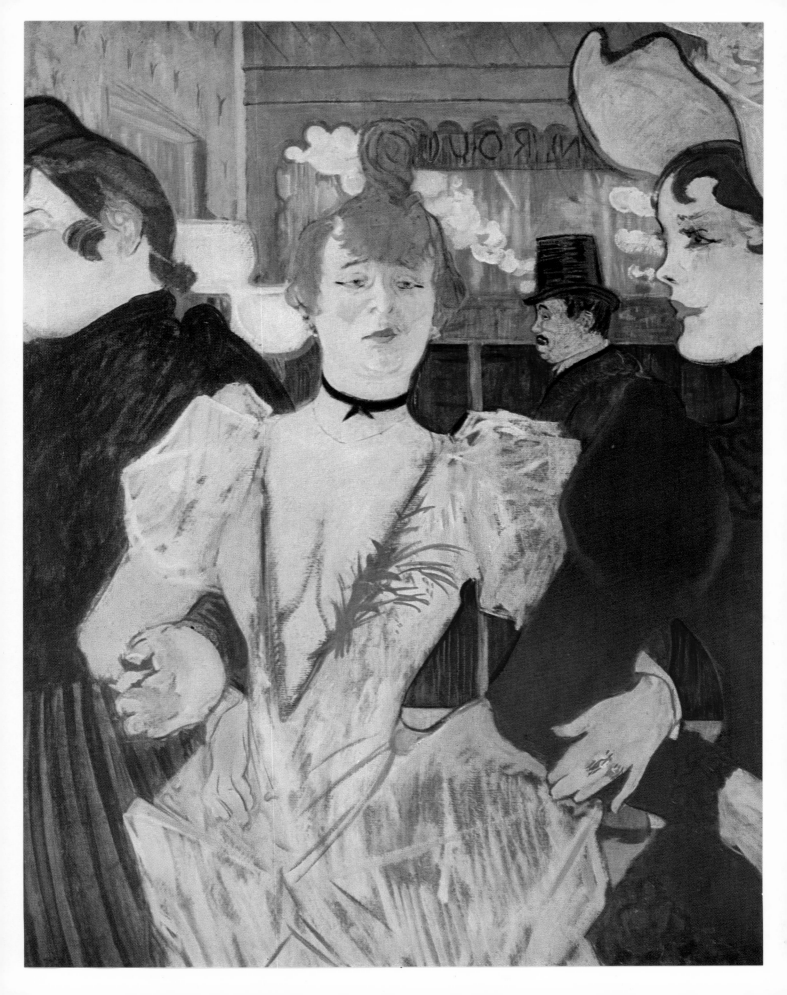

At the Moulin Rouge

$48\frac{3}{8} \times 55\frac{1}{4}''$

THE ART INSTITUTE OF CHICAGO

(Helen Birch Bartlett Memorial Collection)

THIS IS ONE OF THE FEW PICTURES by Lautrec in which his interest has shifted from the dance floor to the spectators in the surrounding *promenoir*. Here, seated at a table, are the critic Edouard Dujardin, with a yellow beard, La Macarona, a Spanish dancer, Sescau, Guibert, and, with her back to us, an unidentified woman. In the background La Goulue is arranging her hair in front of a mirror, while more to the left can be seen Lautrec himself accompanied by his lanky cousin Gabriel Tapié de Céleyran.

In its original form this picture was a straightforward conversation piece in which the spectator was imagined close to the table and looking down on the scene from just behind the back of the woman with orange hair. But Lautrec must have felt that this conception was too illustrative and banal, for at a later stage he enlarged his canvas by ten and three-quarters inches at the bottom and six and one-quarter inches on the right (the joins are visible even in the reproduction), adding a few inches at the top and on the left as well. Then he brought all the pictorial science at his command into play in order to transform the impressionistic or photographic image into a no less realistic but pictorially more effective one.

The principal group of people at table was off-centered and balanced against a close-up of a girl (Mlle. Nelly C.) who was added in the immediate right foreground. The placing (learned from Degas) of this figure, with its masklike face lit from below and cut on two sides by the frame, coupled with the abrupt diagonal of the balustrade, which had to be prolonged, encloses the principal group in a sort of V and draws the eye right into the middle of the picture.

A comparison of this composition with *At the Moulin de la Galette* of 1889 (page 8), which it resembles in so many ways, shows how much Lautrec learned in the interval. Note how in both pictures the diagonal is emphasized, and especially how an illusion of space is created by the converging diagonals of the floor boards and the balustrade. Lautrec shows himself much more expert here in the handling of such Japanese stylistic devices. This is unquestionably one of Lautrec's greatest and most imaginative pictures. The curious but suggestive color harmony in yellow, orange, and green is related to his experiments in poster designing.

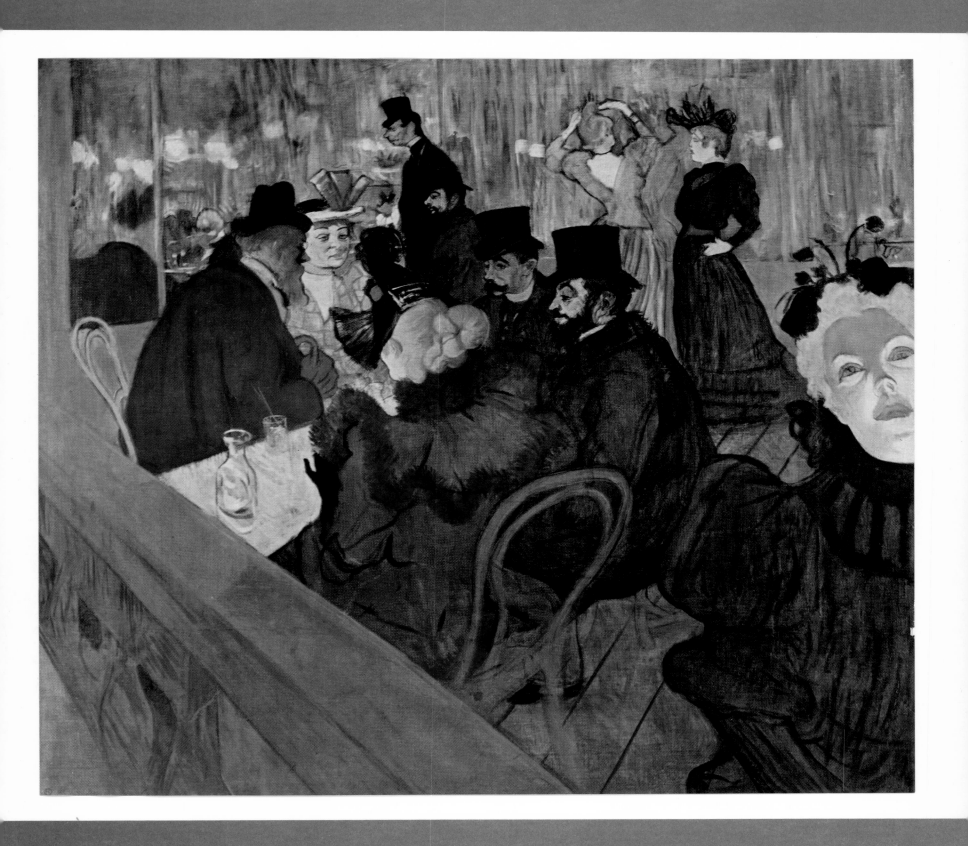

PAINTED IN SPRING 1893, PARIS

M. Boileau at the Café

31½ × 25⅝″

THE CLEVELAND MUSEUM OF ART (*Hinman B. Hurlbut Collection*)

VERY LITTLE IS KNOWN about the subject of this portrait except that he was a friend of Lautrec, as is borne out by the *dédicace* in the top left corner. All that can be established is that he was well-to-do, a *bon viveur*, and a familiar figure in the fashionable cafés of Paris. All of this has been admirably suggested, and with great economy of means, by Lautrec, who has conjured up the essential personality of the man by the tilt of his bowler hat, by his way of holding a cigarette and a cane, and by the glass of absinthe and the dominoes on the table in front of him.

Like *A Corner in a Dance Hall*, this is a group scene, though here no contrast of types is involved and the other figures have only been included in order to provide a background atmosphere to set off the sitter. The similarities in style and conception between these two pictures are, however, obvious. Here one catches echoes of Manet and Degas, and even of a picture such as Courbet's *Mère Grégoire*. Note how by framing the figure between two shallow diagonals—the one of the floor at left and the other the gap between the two tables at right—Lautrec has been able to reduce the effect of depth, so that the sitter stands out in relief against a flat background. The figure in a top hat on the right is the artist's father.

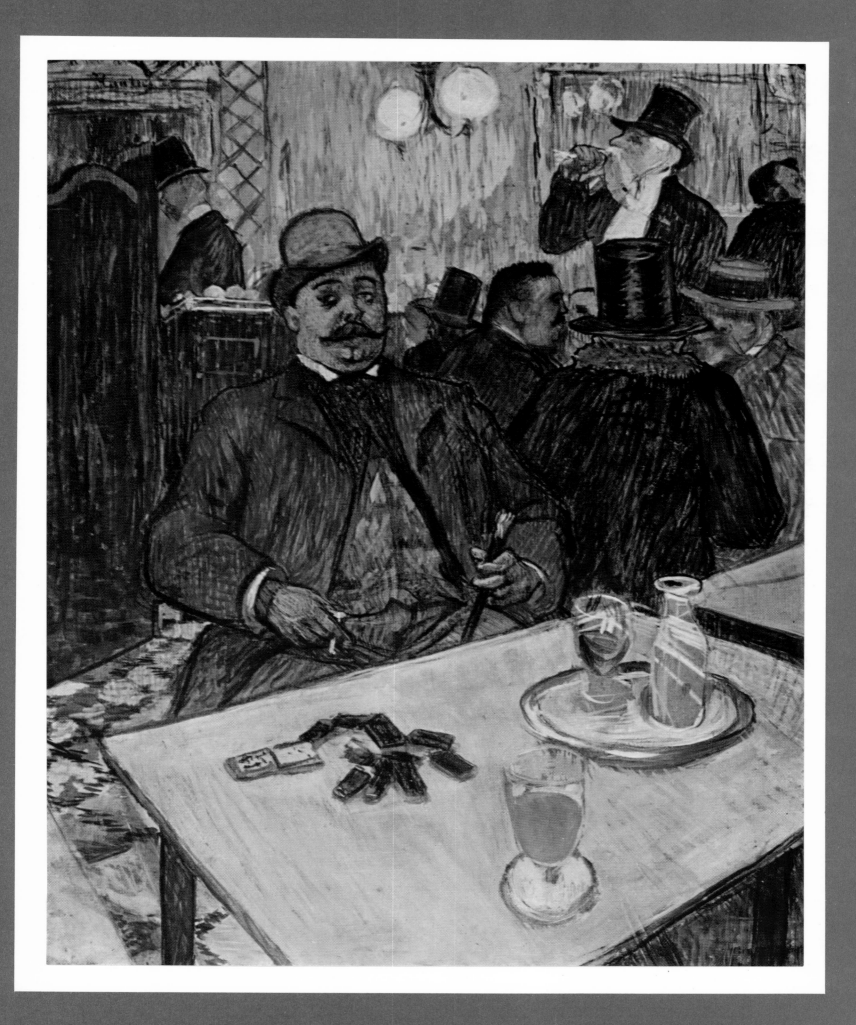

PAINTED IN 1894, PARIS

La Visite: Rue des Moulins

31¾ × 21¼"

NATIONAL GALLERY OF ART, WASHINGTON, D.C.

(*Chester Dale Collection*)

BETWEEN 1892 AND 1895 LAUTREC spent much time in houses of prostitution, even living for several weeks in 1894 in the most fashionable and luxurious establishment in the Rue des Moulins. Thus he was familiar with every aspect of the daily routine there and was able to make paintings of the girls performing their toilette, or making their beds, or playing cards in an off moment, and even of the laundryman delivering a bundle of washing which is being checked by *madame* in her dressing gown.

Among these paintings are some glimpses into the more intimate life of the girls, as for example here where they are shown parading for the medical inspection to which they were obliged to submit at regular intervals as a precaution against the spread of venereal disease. In spite of its unpleasing subject and the possibilities of indulging in salaciousness, Lautrec has made a picture which is neither pornographic nor erotic. If we compare it, for example, with similar works by Félicien Rops (1833–1898) or Rouault, we shall see at once the great difference in approach. Where the others exploit the element of eroticism or grossness, Lautrec accepts what he sees without comment and is content to set it down on canvas naturalistically. There is no primness and no sense of shame in the posture or expressions of these two girls, who are subtly characterized, nor has Lautrec tried to disguise their indifference by introducing a note of *roguishness* in the manner of Boucher. The inspection is merely a part of the boring routine of their daily life and they are presenting themselves unself-consciously. One of the most remarkable and estimable characteristics of Lautrec's artistic vision was this ability to see and record impartially.

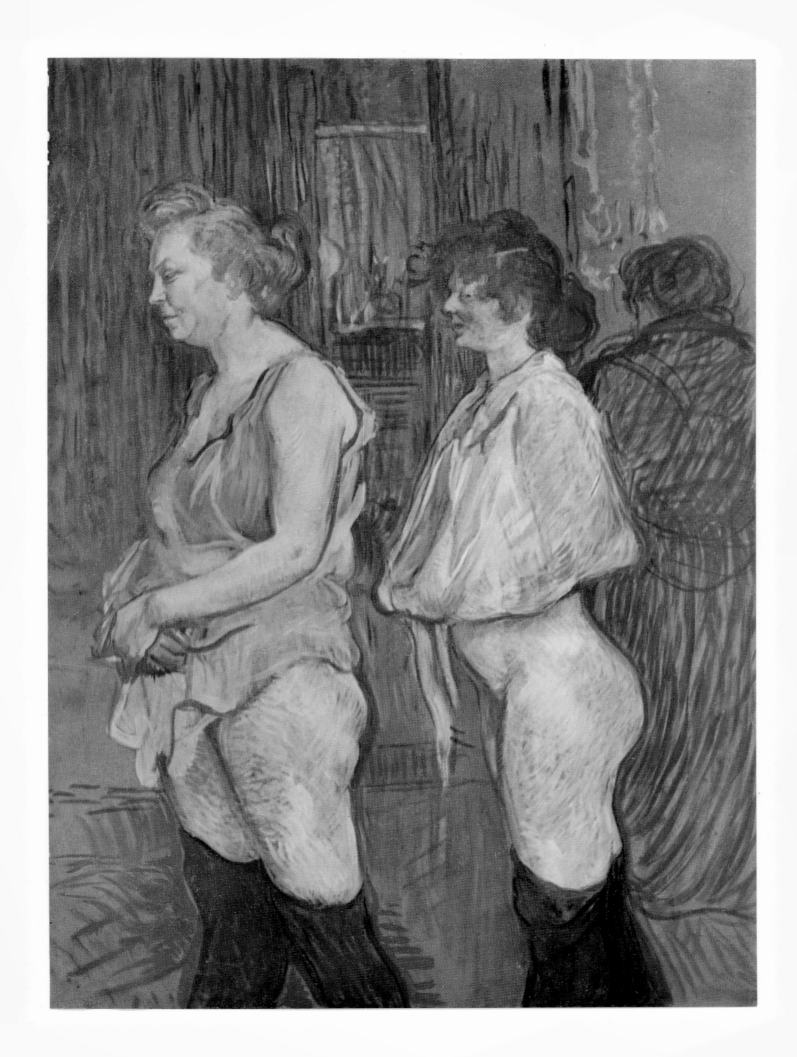

PAINTED IN 1894, PARIS

The Salon in the Rue des Moulins

43 ¼ × 51 ⅛"

MUSEUM OF ALBI, FRANCE

LAUTREC'S INNUMERABLE STUDIES of life in the *maisons closes*—between 1892 and 1895 he painted more than fifty pictures and made hundreds of drawings—were destined to culminate in one great painting entitled *The Salon in the Rue des Moulins*, which he executed in 1894–1895. Ours is not, however, the final picture but the elaborate pastel sketch which immediately preceded it. It is rather broadly executed, has been left unfinished in many parts, and is pallid in tonality. The painting which followed it, on the other hand, is very finely and carefully painted and is carried out in an extraordinary harmony of pinks, mauves, and reds with notes of green and black which create a hothouse atmosphere evocative of the place itself. Exotic decoration was very much favored in these establishments and here, for example, the scene has been set in a Moorish salon. The girls are lolling around, in various stages of undress, waiting languidly for the arrival of the clients. On the right, primly erect, her hair piled high and falling in a fringe over her forehead, sits the *madame*, responsible for order and decorum.

This is one of the few important compositions which Lautrec made from memory and imagination. For it was elaborated by him in the studio during several months from studies of virtually all the individual figures, as well as of the architectural features and the furniture; there is also a study of the group of two women in the left background, while the half-figure of the girl lifting her petticoat on the right is based on a drawing made in 1893. This same salon appears also in an earlier picture, *Le Divan* (1893), and it was in the Rue des Moulins that Lautrec made most of the drawings for his important series of lithographs, *Elles* (1896).

Note how, in the manner of Seurat and Gauguin, Lautrec has here evaded the spatial problems involved by avoiding modeling and relying on a combination of profile and full-face views.

Lautrec probably did not finish painting his great composition until late in 1895; its completion marks the end of his artistic interest in *maisons closes*.

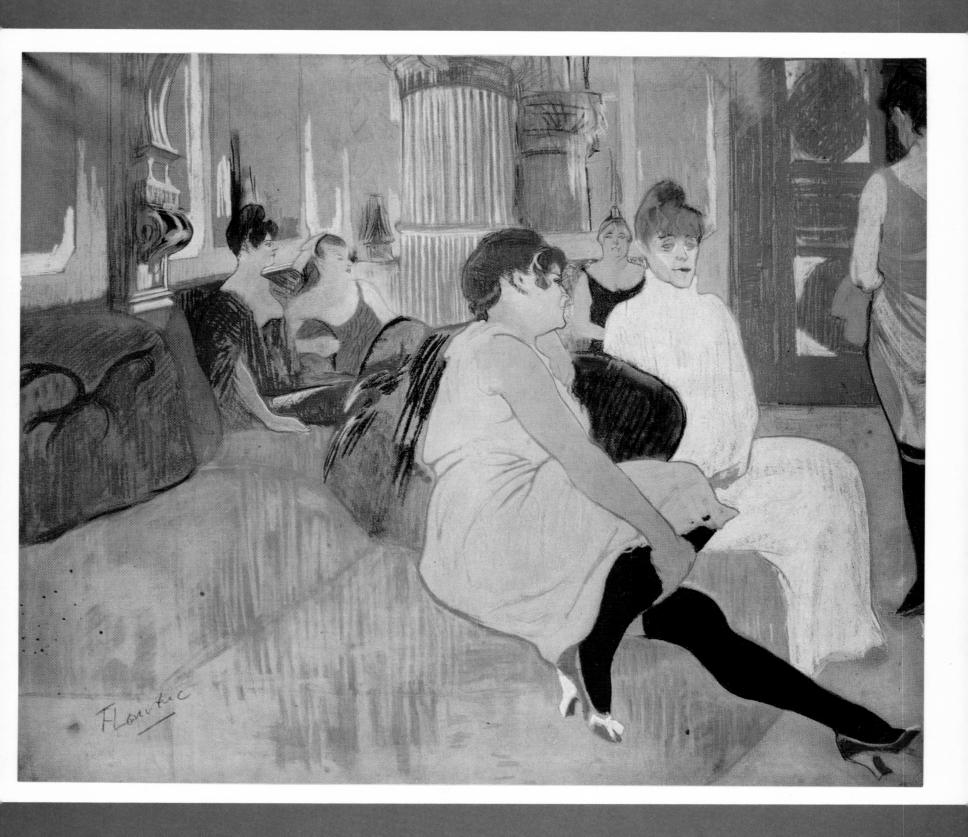

PAINTED IN 1896, PARIS

Maxime Dethomas
at the Opéra Ball

$26\frac{1}{2} \times 20\frac{3}{4}''$

NATIONAL GALLERY OF ART, WASHINGTON, D. C.

(Chester Dale Collection)

THIS IS A PORTRAIT which can be compared with an earlier one of M. Delaporte. Both are given an imaginary setting: the latter as a spectator at the Jardin de Paris; M. Dethomas at a masked ball at the Opéra. The present picture is, however, different, for it is not a portrait in the accepted sense, since the artist has not been concerned either with analyzing the sitter's character or with catching a likeness. The serious figure in dark clothing—whose features are only partially visible—exists rather as a foil to the revelers in the background. We are told even less about his personality or appearance than we are about that of Tristan Bernard in another portrait which is comparable.

Maxime Dethomas (1868–1928), a painter and engraver, was one of Lautrec's closest friends from the early 1890's till the end of his life. He was very tall and corpulent, but also an exquisite and gentle man of whom Thadée Natanson writes: "He was so frightened of wearing anything that might draw attention to himself that even the black of his clothes seemed duller than that worn by others." And Paul Leclercq adds that what fascinated Lautrec about Dethomas was "his ability to preserve an impassive appearance even in a place of amusement." This we may take as a revealing comment and apply it to the present picture.

In 1895 Lautrec spent part of the summer on the Normandy coast with Dethomas, who drew a portrait of him (now in the Museum of Albi). In 1897 they made a trip to Holland together and visited the Frans Hals Museum at Haarlem. Dethomas' work was greatly influenced by that of Lautrec.

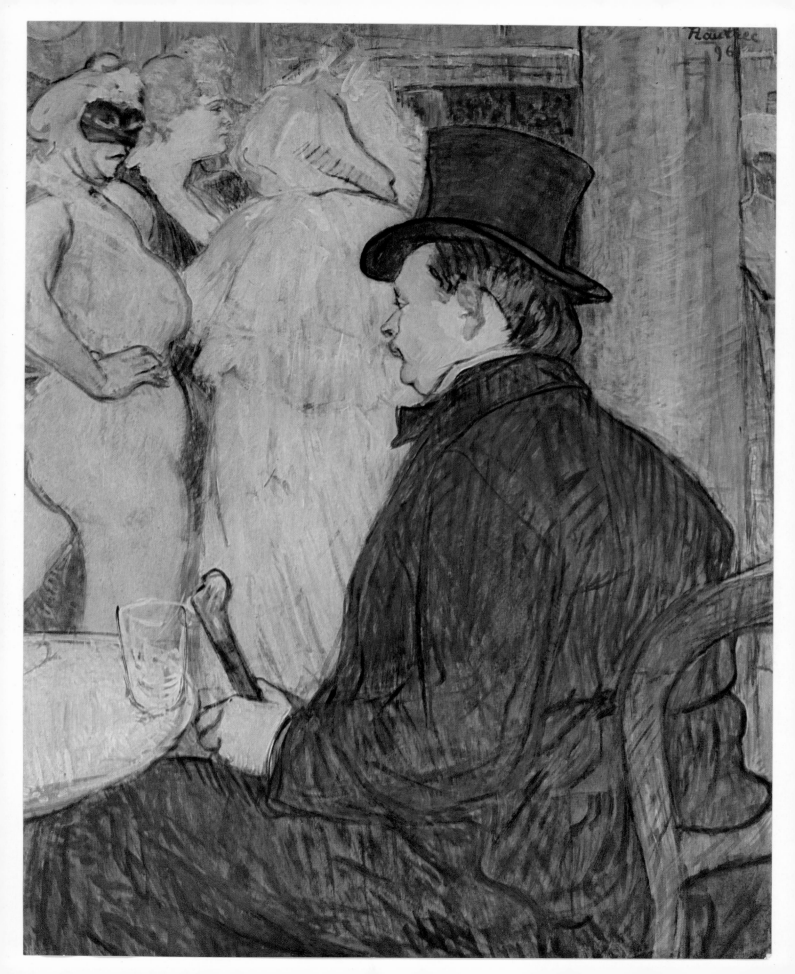

PAINTED IN 1896, PARIS

La Toilette

$25\frac{3}{8} \times 20\frac{7}{8}''$

MUSEUM OF IMPRESSIONISM, THE LOUVRE, PARIS

AT THE BEGINNING OF 1896 Lautrec was at work on a series of lithographs in color which were published in May as an album entitled *Elles*. With one exception—a portrait of Cha-U-Kao (page 9)—all these lithographs represent women in bed or performing their toilette and seem to be based on drawings he had made earlier in *maisons closes*. Much of the inspiration must have come from Degas. Probably his work on these lithographs encouraged Lautrec to forget about clothes and scenic effects for a while and concentrate instead on the anatomy of the human figure. At all events, in 1896 he made several studies including the present one, of women in various stages of undress, which appear to have been posed for him in the studio. In another picture of this date—*Model Resting*—posed by the same girl, we can identify much of the same furniture.

From the technical point of view this is one of the most accomplished pieces of painting in Lautrec's oeuvre. It is also curious in that it is one of the rare works in which he has not been concerned with a face. Presumably an exercise in the manner of Degas, whom Lautrec admired so much.

34

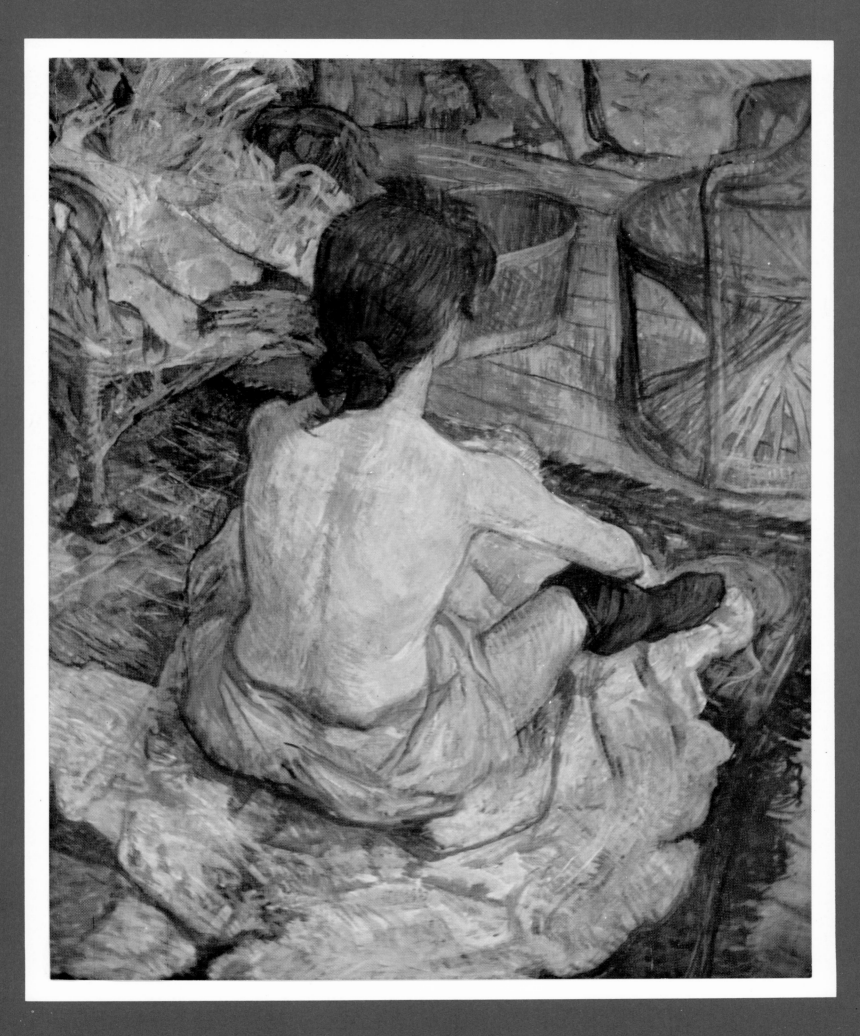

PAINTED IN 1900

Woman at Her Toilette:
Mme. Poupoule

24×16″

MUSEUM OF ALBI, FRANCE

HERE LAUTREC TAKES UP AGAIN a subject which he had treated more than ten years earlier. There is, however, a great difference in treatment between the two works. In the earlier picture Lautrec was concerned with emphasizing the character of the woman and her artifice, whereas here he has been interested in finding the correct tonality for the painting of her hair and her dressing gown. In this picture Lautrec pays homage to Manet as well as to Degas, but unfortunately he had neither the virtuosity of the one, nor the superb craftsmanship of the other. This is not merely a colorless picture, it is also flat and lacking in vitality. One need only turn the pages of this book to discover how monotonous and subdued Lautrec's use of color was in his paintings: in his lithographs exactly the opposite was the case.

This picture is generally dated 1898, but there exists another version of this subject, very similar in style and coloring and with the same woman (though seen from a slightly different angle), which is signed and dated "1900." There seems good reason therefore for revising the date of the present work.

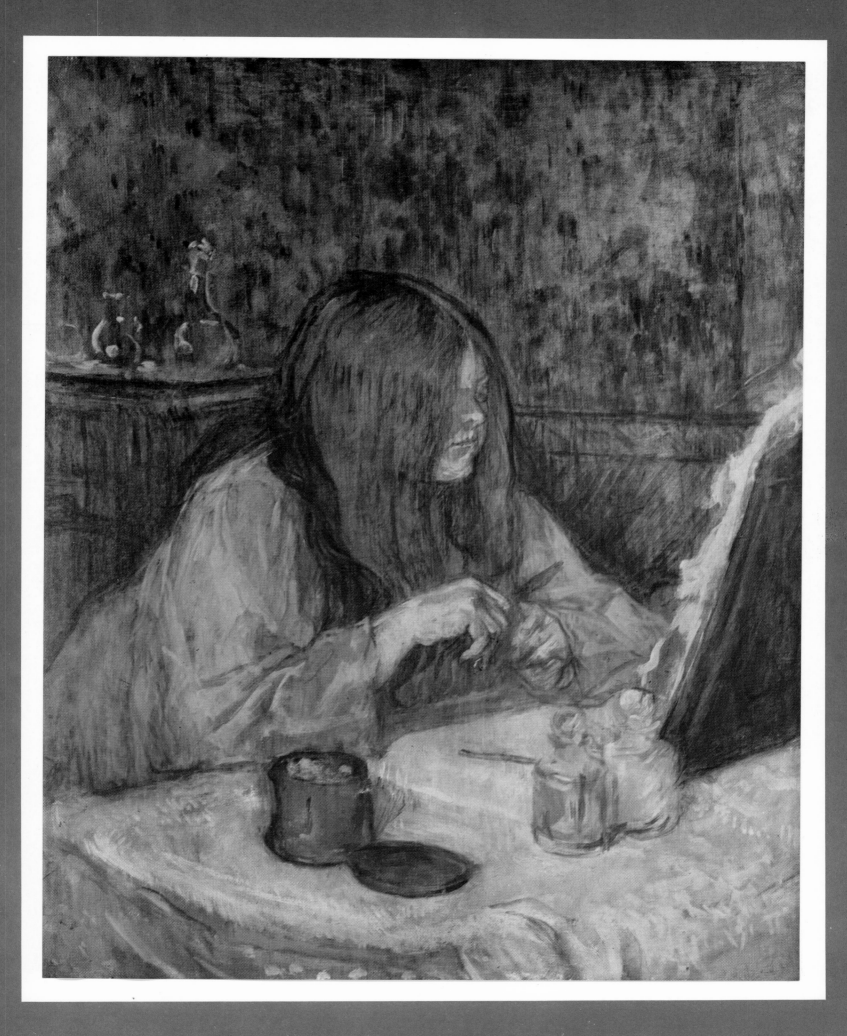

PAINTED IN WINTER 1899, PARIS

Private Room at Le Rat Mort

21½ × 17¾″

COURTAULD INSTITUTE OF ART, LONDON

(Courtesy of The Home House Trustees)

THIS PICTURE WAS PAINTED some two years after the *Nude in Front of a Mirror*. In the interval Lautrec had passed through a crisis of alcoholism followed by a complete mental and nervous collapse. At the beginning of 1899 he had been interned for three months in a sanatorium. After his release Lautrec left Paris for a long convalescence in the country, but apart from a few pictures painted at Le Havre in July, he does not seem to have started working again seriously until he returned to Paris in November. At this time he became very friendly with Edmond Calmèse, the owner of a livery stable near his studio in the Rue Fontaine, and this friendship was reflected in a great many paintings, lithographs, and drawings of horses, carriages, dogs, and riders executed during the next twelve months.

Lautrec was not slow, however, to yield to the temptations of the city. During his convalescence he had remained sober and had made a good recovery, but once back in Paris he rediscovered his old haunts and his dissolute companions and began to drink heavily. The present picture is a portrait of a well-known *demimondaine*, Lucy Jourdan, and is said by Schaub-Koch to have been commissioned by her lover the Baron de W. The man on her left is not, as has been suggested, the Australian painter Charles Conder. Appropriately, Lautrec has imagined her partaking of a tête-à-tête supper in a private room at a fashionable restaurant, Le Rat Mort in the Rue Pigalle.

This is one of the best examples of the painterly style which Lautrec developed during the last two years of his life. Gone is the biting, swinging line of his earlier work; here he has begun to rely on tonal values.

The result, Lautrec's nearest approach to traditional *belle peinture*, is less incisive than before, but in some ways subtler. The effect of the light shining through the gauze headdress and catching the auburn hair, the slit eyes, and the contemptuous smile of the woman is managed with considerable mastery. The handling of the still life, on the contrary, is clumsy. *Gens Chics* of 1893 represents a similar subject handled in Lautrec's earlier manner.

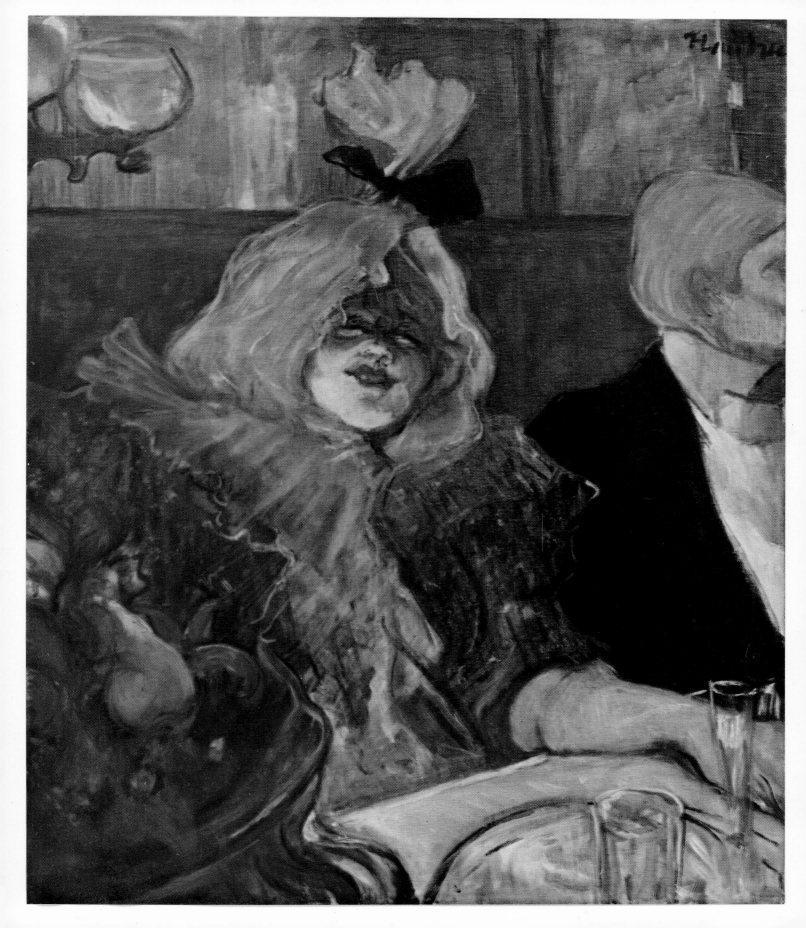

PAINTED IN SPRING 1900, PARIS

The Modiste

24 × 19⅜"

MUSEUM OF ALBI, FRANCE

AMONG THE SCHEMES thought up by Lautrec's friends to provide distraction and prevent him from drinking was that of interesting him in the displays at the fashionable dressmakers in the Rue de la Paix. But Lautrec found the whole atmosphere artificial and the poses of the mannequins too studied to be of interest to him artistically. He did, however, paint this portrait of a friend who was a modiste, Mlle. Renée Vert (Mme. Le Margouin), who had a shop at 56 Faubourg Montmartre. Lautrec had known Renée Vert for many years—he had made a drawing of her arranging hats in her shop in 1893, and had subsequently used this as a menu decoration—because she was the mistress of his friend Joseph Albert, a painter. Albert had been responsible for introducing Lautrec's work into the Salon des Artistes Indépendants in 1889, and in 1893 had sponsored the inclusion of two of his posters at the Salon des Peintres-Graveurs Français. In recognition of these kindnesses, Lautrec made a lithographic portrait of Albert entitled *Le Bon Graveur* (1898) and several drawings of Renée Vert in 1899–1900.

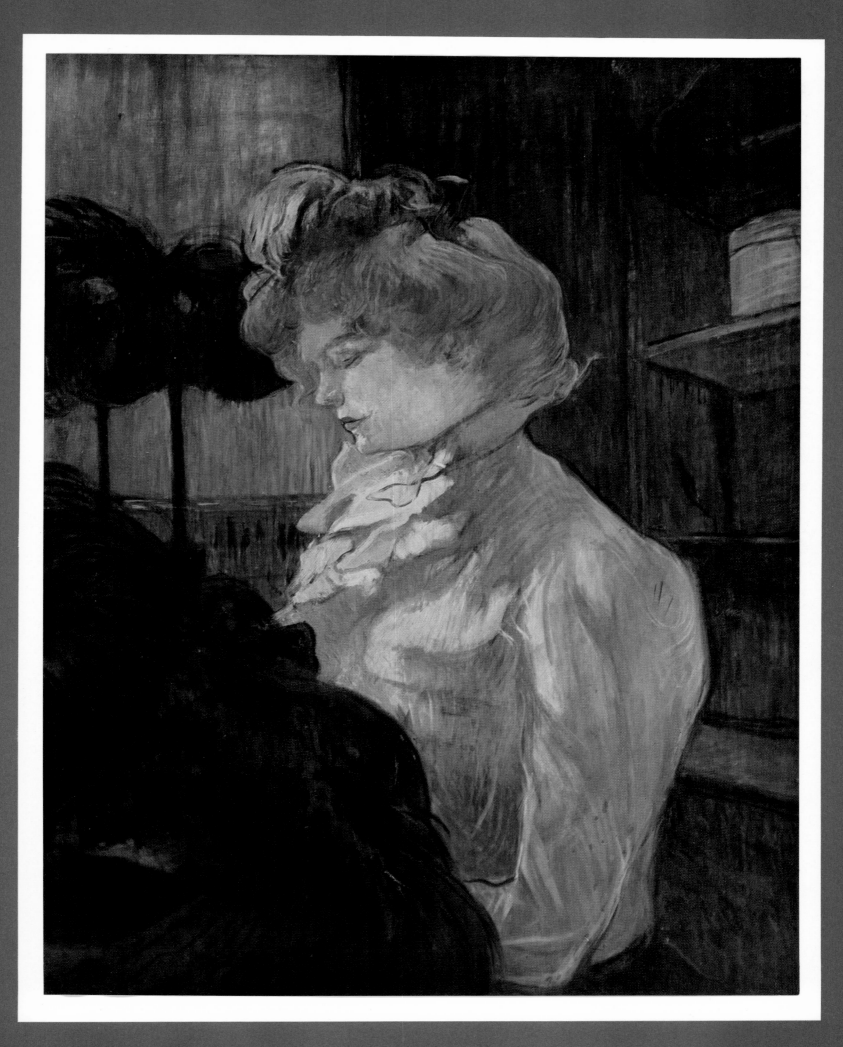